South Bay Contemporary Gallery
San Pedro, California

January, 2017

The Faces Within

Curated by Karrie Ross

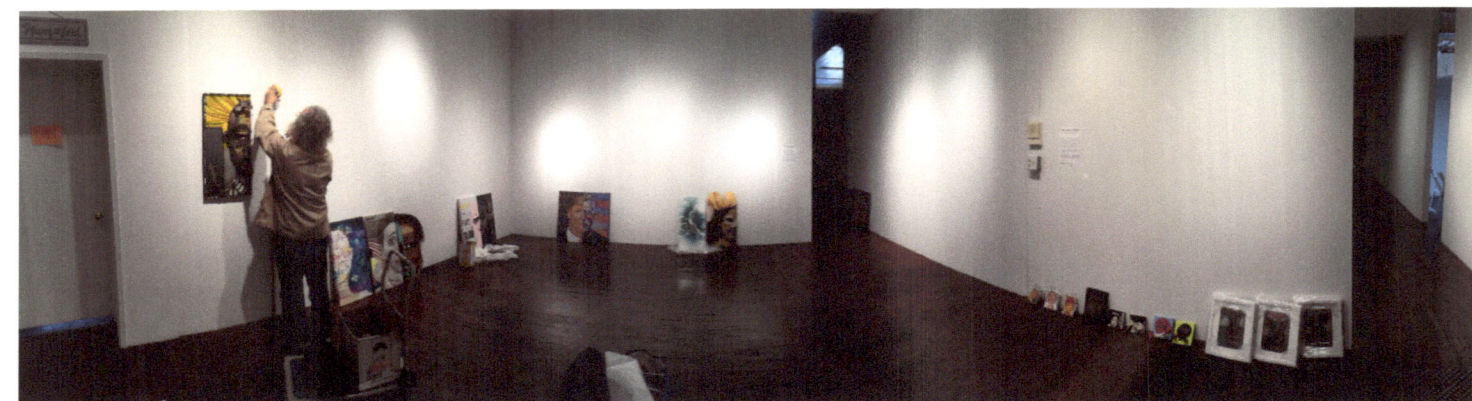

The Faces Within

Curated by Karrie Ross

Copyright © 2017 Karrie Ross

All rights reserved. Except as permitted under U.S. Copyright Act of 1976, no part of this publication may be reproduced, distributed, or transmitted in any form or by any means, or stored in a database or retrieval system, without the prior written permission of the publisher.

Karrie Ross: 708 W. 140th Street, Gardena, CA 90347
Visit her website at www.KarrieRoss.com.

Image use is prohibited without written concent of the artists. All art copyright respective artist.
Printed in the United States of America
Book Design by Karrie Ross

The Faces Within

The Artists personal responses to their mental/physical/emotional state during this 2016 election past year.

Curated by Karrie Ross

FACES WITHIN: We all experience the pull of emotions and the recent Presidential election of 2016 has brought many, if not all, of us to points of realization of about what, why, how we think, and feel. The question the artists were posed with is "What Does YOUR emotional FACE Look Like?" Each Artist was assigned a left or right side of face to create. Some started their projects before November 8th and others after, the results are amazing, I hope you'll be able to relate to, and find a connection to, their feelings. There will also be some small pieces reflecting a full face and one emotion.

Karrie Ross (on right) works as an exhibition curator, art-book-project organizer, installation, award winning visual artist, and author, based in Los Angeles. Her art practice extends into inspiring and how-to presentations for groups and schools in the Southern California area with plans to grow it over time. She is self-employed, working in advertising, marketing and promotion for over 35 years helping individuals and companies create an on- and off-line brand presence. Karrie is a certified Life Coach, offers consulting as a "muse coach" to help you find a best path platform for you and your art to follow.

January, 2017

The Faces Within

20 Southern California based Artists

Nancy Larrew

Sarah Stone

Ben Zask

Steve Shriver

Scott Meskill

Anna Stump

Vicki Barkley

Raymond Logan

Randi Matushevitz

Malka Nedivi

Leonard D Greco, Jr.

Beanie Karman

Lore Eckelberry

Cansu Bulgu

January, 2017

The Faces Within

The Faces Within

January, 2017

The Faces Within

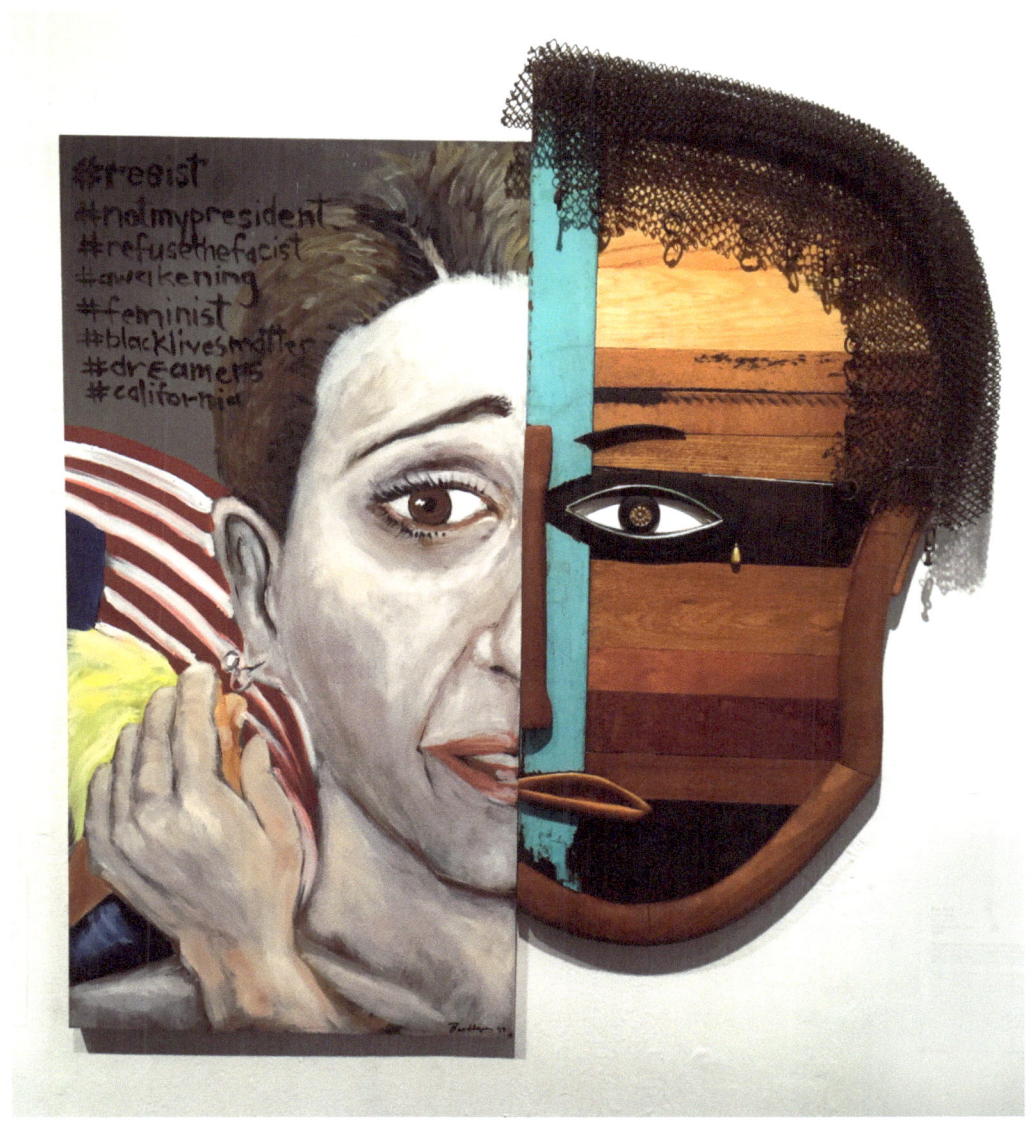

Vicki Barkley and Ben Zask

January, 2017

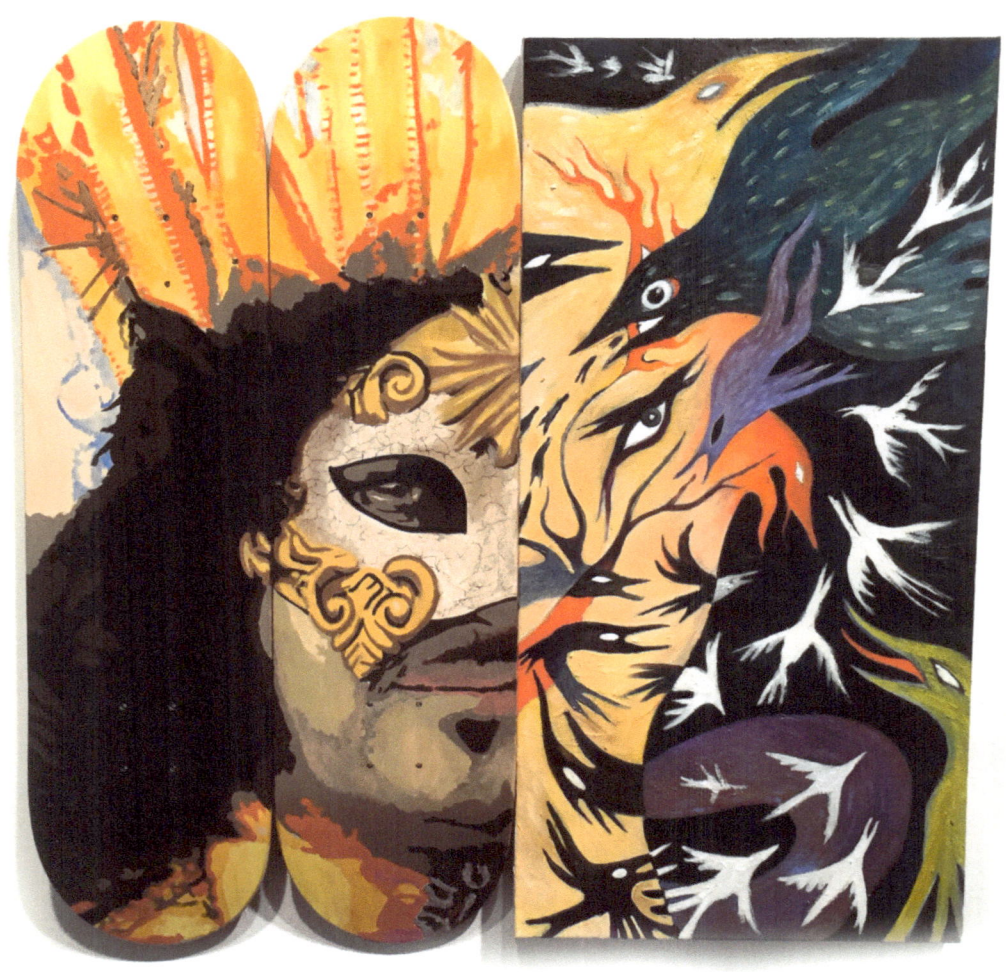

Lore Eckelberry and Sarah Stone

The Faces Within

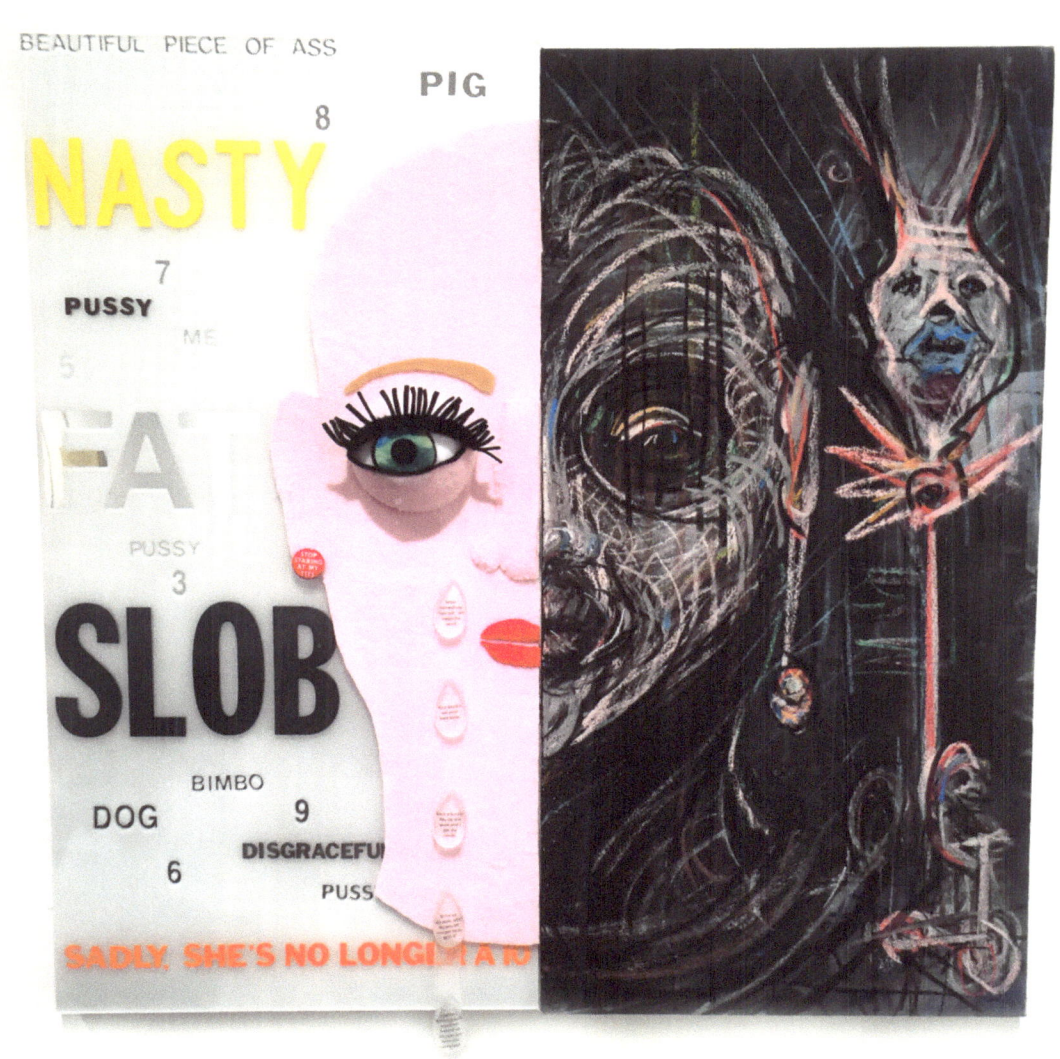

Nancy Larrew and Randi Matushevitz

January, 2017

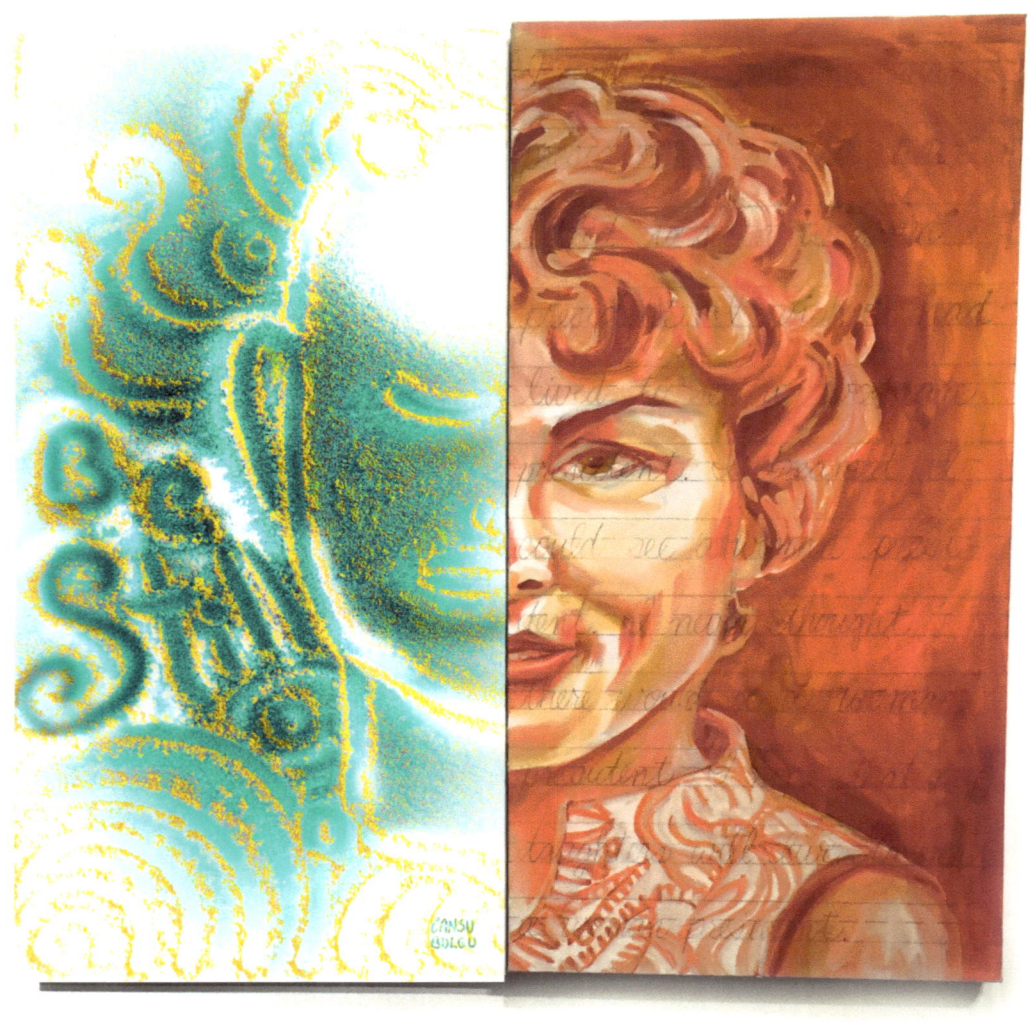

Cansu Bulgu and Anna Stump

The Faces Within

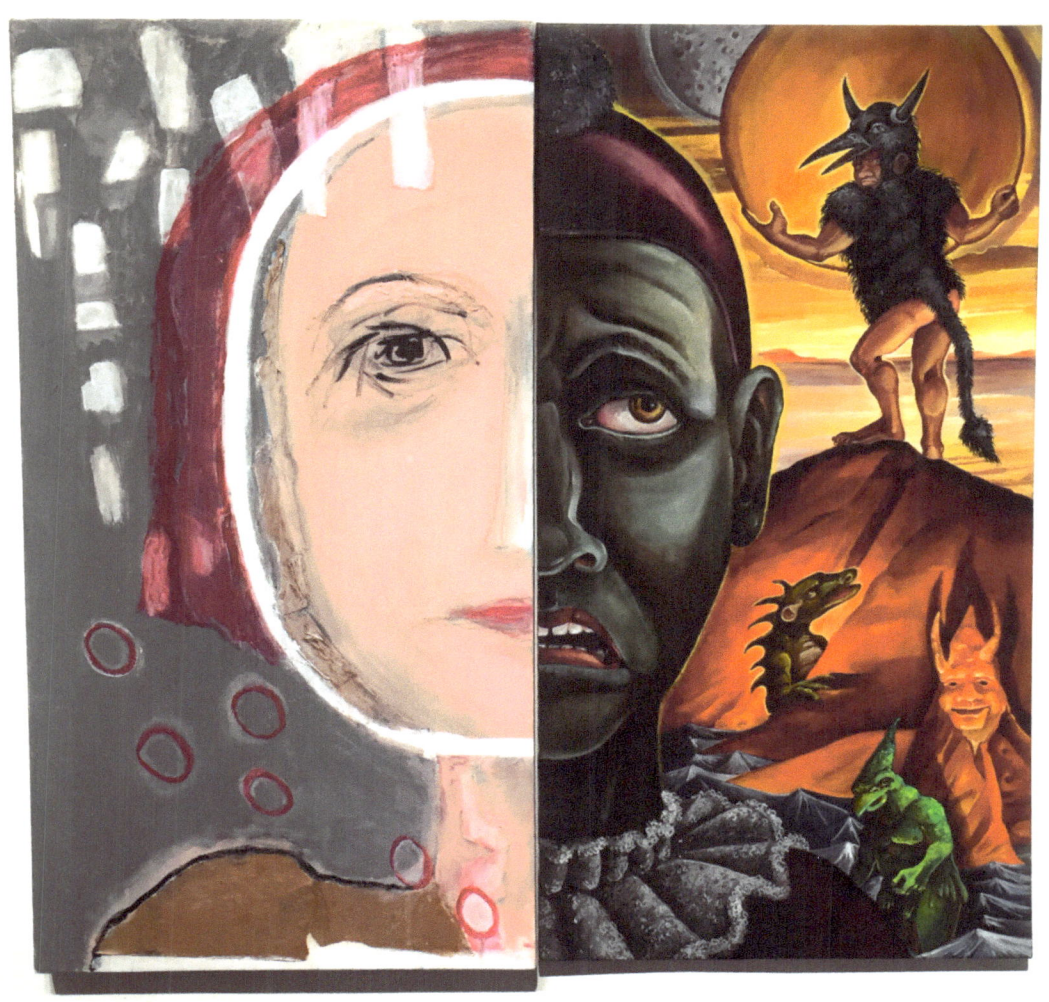

Malka Nedivi and Leonard D Greco, Jr.

January, 2017

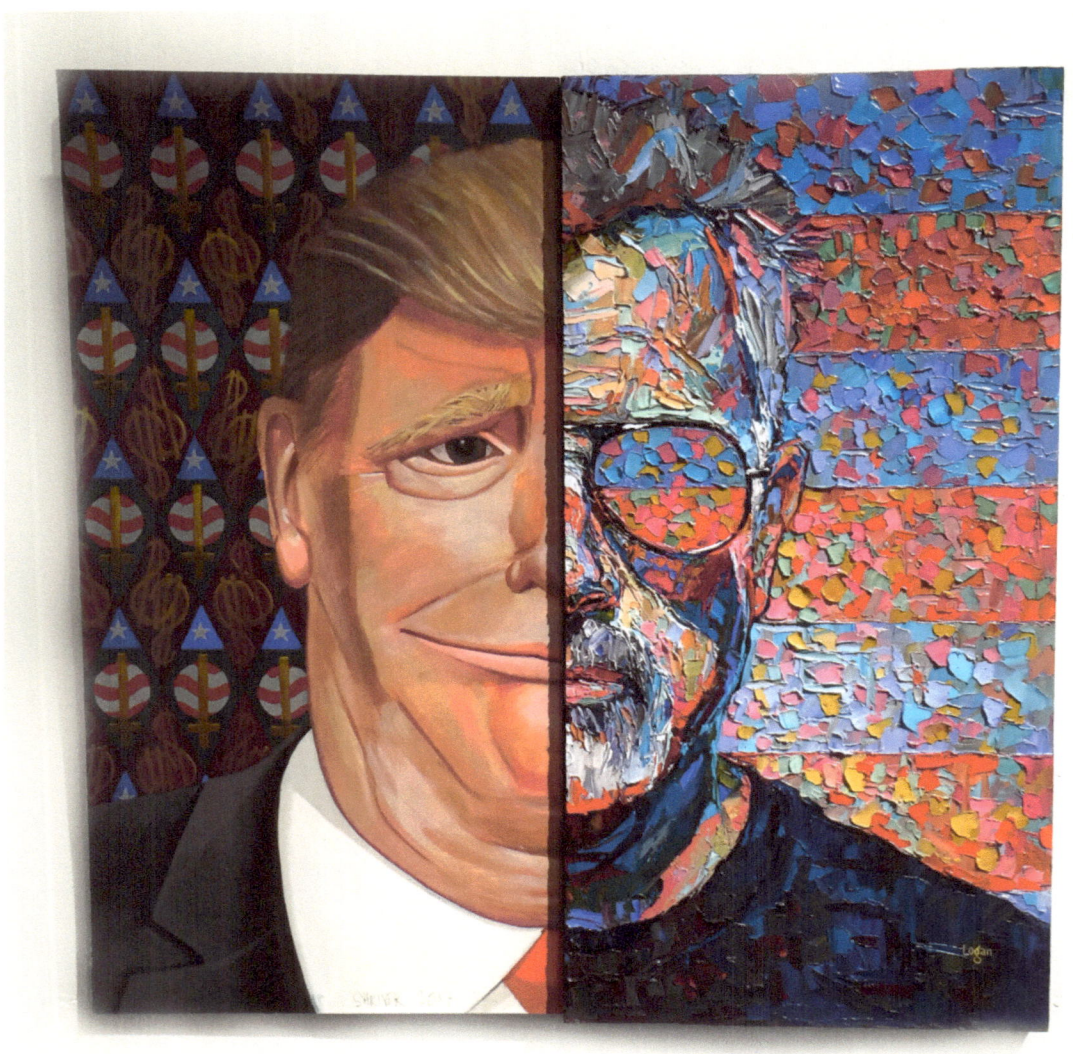

Steve Shriver and Raymond Logan

The Faces Within

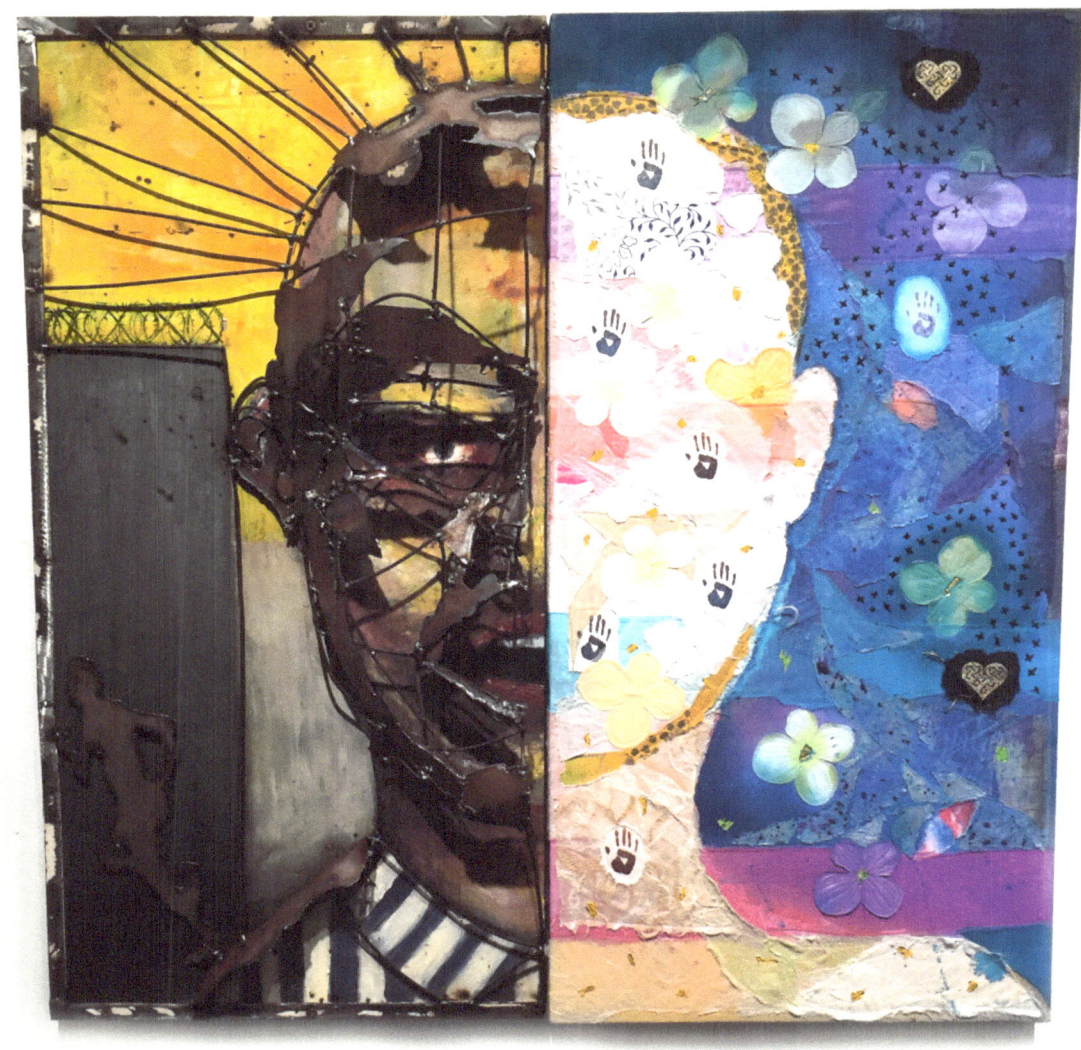

Scott Meskill and Beanie Kaman

January, 2017

Scott Meskill
The Faces Within

Misunderstood, Unknown, Nuclear, War, Hacking, Russians, Deniability, Lies, Hate, Bigotry, Misogyny, Racism, Disgust, Run, Move, Respond, React, Read, Post, Eat, Rally, Protest, Concern, Mourn, Discuss, Blame, Shame, Unrest, Work, Sit, Stand, Think, Wonder, Relive, Dwell, Angst, Paranoia, Taunt, Tease, Judge, Misjudge, Fake, Fraud, Bully, Crook, Doubt, Stress, Pain, Sleepless, Uncomfortable, Uncontrollable, Unconscious, Unreasonable, Unthinkable, Toxic, Septic, Environment, Bankers, Billionaires, Power, Corruption, Disillusion, Humanity, Insane, Uneducated, Middle Class, Struggle Immigrants, Walls, Borders, Ignorant, Unreal, Drama, Cover Up, Self-Interest, Conflict, Mislead, Terrorism, Threat, Grab, Entitled, Prick, Flush, Do Over, Rewind, Curse, Vomit, Decide, Divide, Dismiss, Normal, Devoid, Knowledge, Learn, Grow, Hope, Plan, Fight!

www.scottmeskilldesigns.com

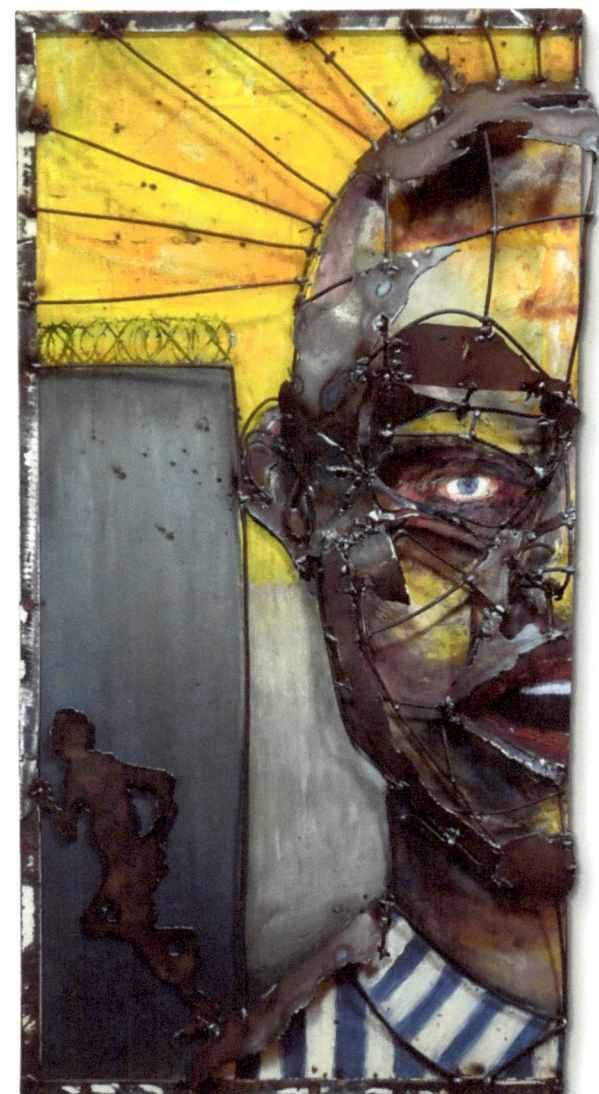

Departure
30" x 15"
Hardboard, Oil, Steel Wire, Sheet Metal

Beanie Kaman
The Faces Within

For me, making this artwork was particularly challenging, as I shy away from politics and I never represent the face or humans in any sort of manner. I find politics to be a matter of rhetoric with little honesty, and humans too often engage in politics to exhibit their worst behaviors. To find myself working within these ramifications caused a certain amount of unease. I wanted to rise to the challenge and worked my way thru, examining these these two aspects and how I could relate. I found myself resorting to the images that I am most comfortable with, in this case, flowers and sky. And the "flower child" naturally appeared. The anti-war, counter culture hippies made all the sense in the world to me in the '60's, and in these most troubling times, again their message of peace and love is as eternal and idealistic as it ever was.

www.beaniekaman.com

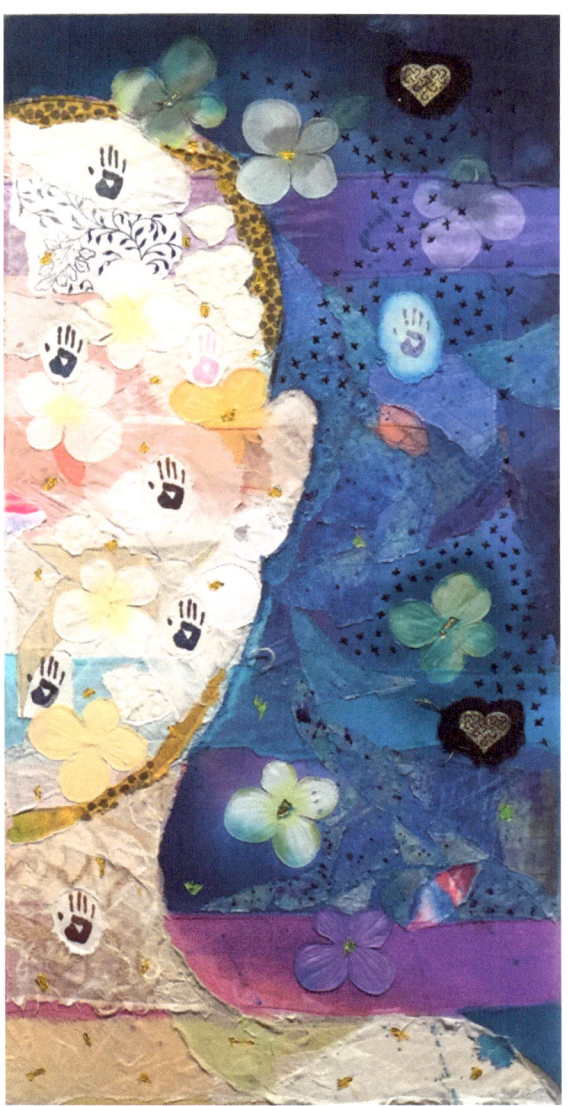

Flower Child
30"x15"
mixed media on canvas

January, 2017

Cansu Bulgu
The Faces Within

Life lives through us both subjectively and collectively at once. "Be still and know that I am..." is an invitation to welcome the aliveness of this paradox. The day brings with it many emotions, challenges and opportunities. In response, our faces may take on many forms. When we soften our gaze, however, we may find ourselves viewing life in ways we haven't viewed before. May this piece remind you of our collective "One True Face With In" and the vast inner peace that is ever present. "See what you cannot see, for what is essential is invisible to the eye."

www.cansuart.com.

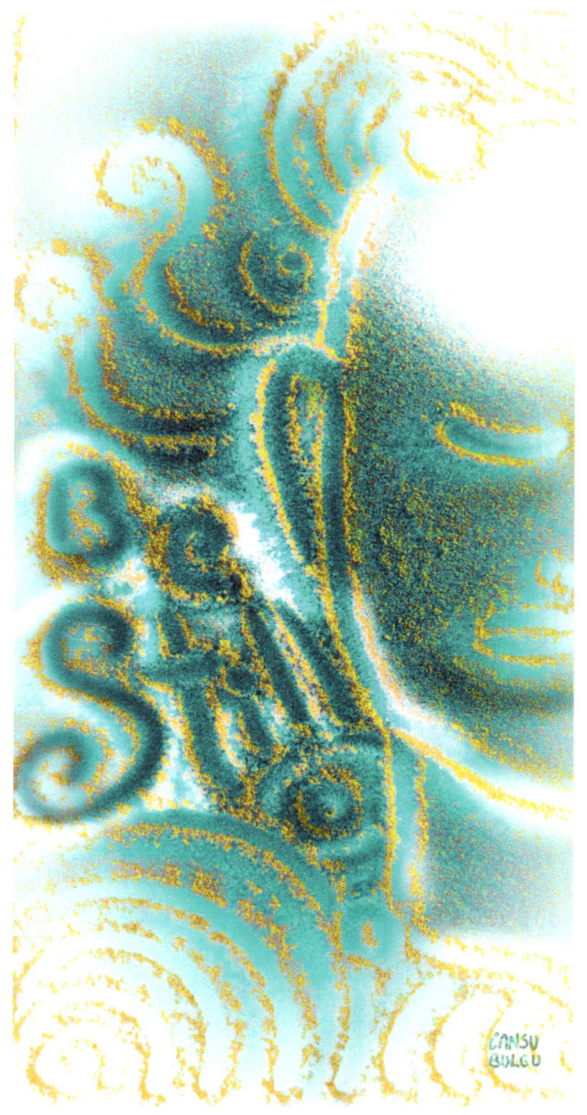

Be Still And Know That I Am
30"x15"
Medium: Mixed New Media, Cansu Bulgu's signature creative process of meditation with the Elements, sculptural sand drawing, photography, digital light painting and printing on metal.

Anna Stump
The Faces Within

I will never see a woman president. I would have liked to see a woman president. I wish I had lived to see a woman president. I dreamed I could see a woman president. I never thought there would be a woman president. I hope my daughters will live to see a woman president.

www.annastump.com

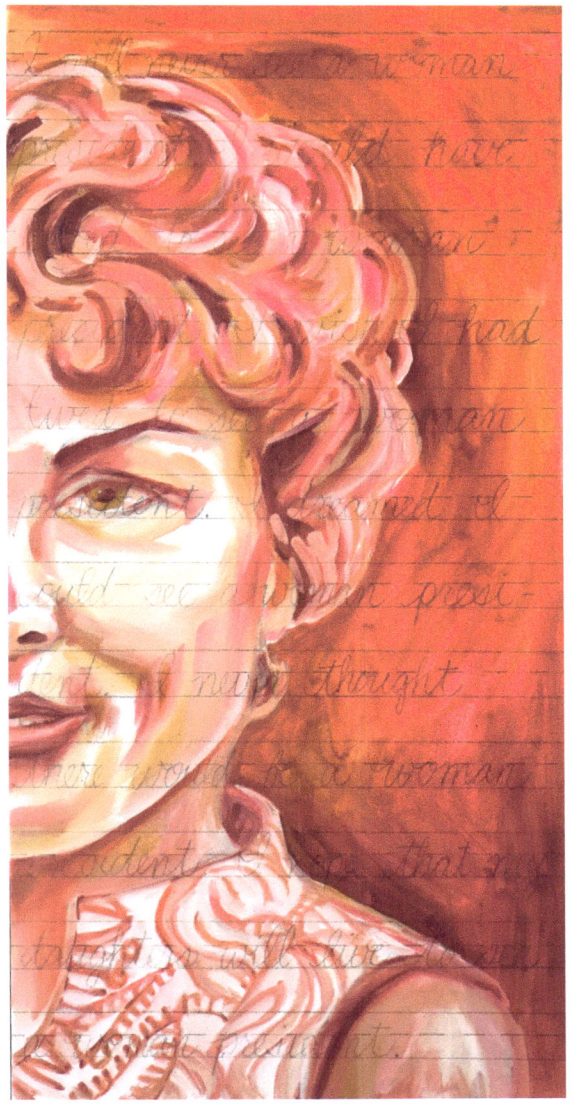

I Will Never See a Woman President
30" x 15"
oil and graphite on canvas

January, 2017

Steve Shriver
The Faces Within

My piece is about the clown we have hired to lead this country for the next four years. His facial expressions sum up my reaction to the election. The background, like his own, is where the content is."

www.steveshriver.com.

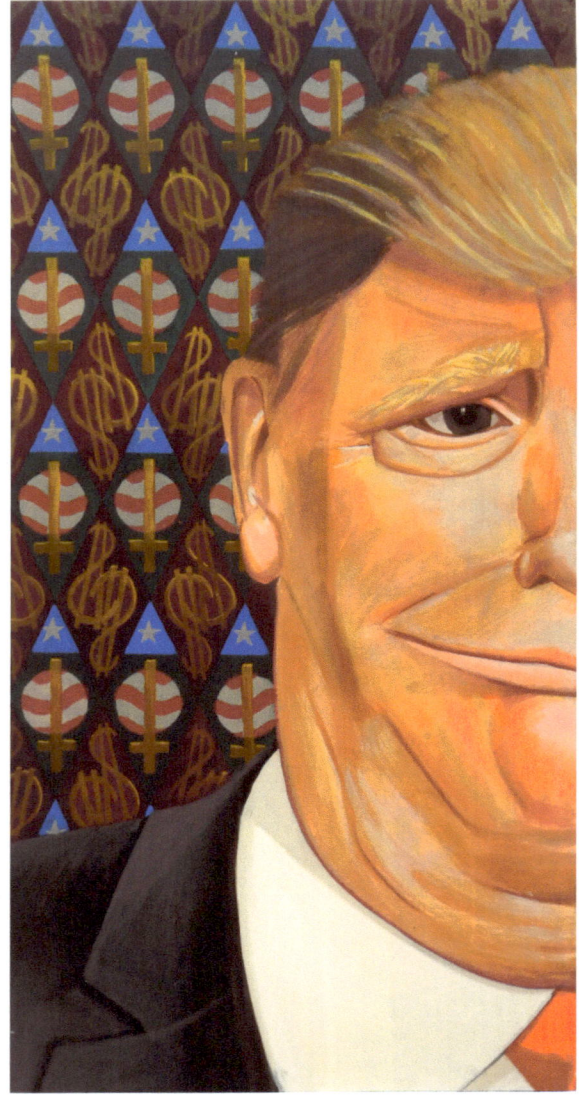

Halfa Trumpclown
30" x 15"
Acrylic on matboard

Raymond Logan
The Faces Within

I'm wondering where the adults in the room have gone. The more we move to extremes, the more adults seem to exit the room. When there are too few to say, "Now play nice, they actually have a point and you should consider it," or to simply identify what is right or wrong or—in grayer situations—apply a mature and fair hand, we are left with people yelling at each other or off weeping in the corner not participating. My optimism hopes the adults haven't shirked their responsibilities, but are just over at the sandbox taking a coffee break.

www.raymondlogan.com

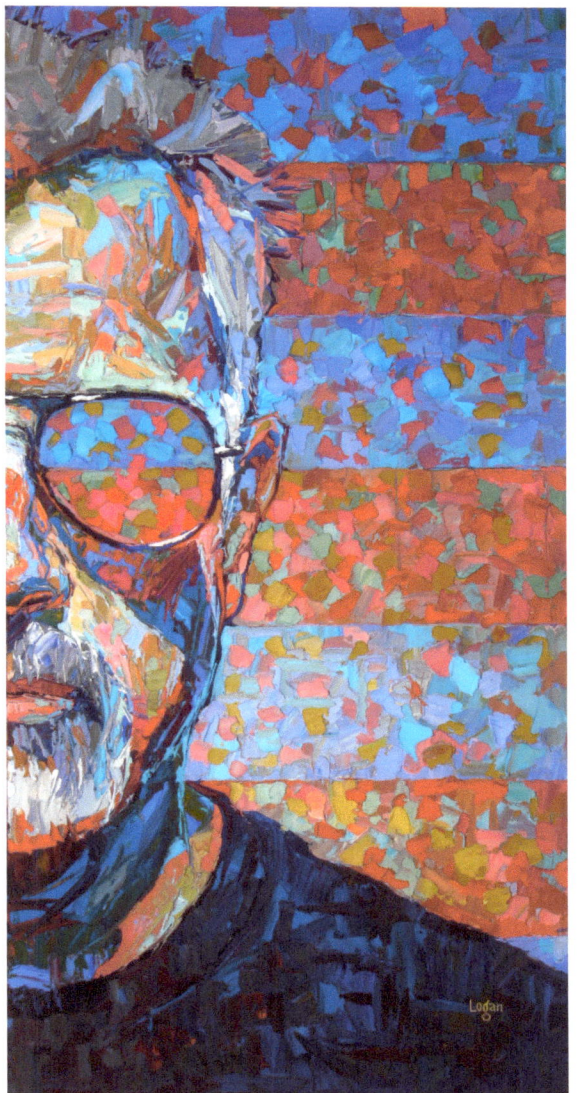

Torn
30" x 15" x 1 3/8"
Oil on Canvas

January, 2017

Vicki Barkley
The Faces Within

My State of the Union is stronger than it knows itself to be. There is a menace, which we've always known, and we have brought its fear, racism, and misogyny out into the open. We elected a puppet, a grifter, a predator, into our most powerful office. Sixteen years ago, I believed we had done our worst. Now I see we have unlimited capacity to make mistakes, act on our basest natures, and burn down our own house rather than face history and ourselves. This gives us the opportunity to brighten our lights and show ourselves back into the light of our promise.

www.facebook.com/vicki.barkley

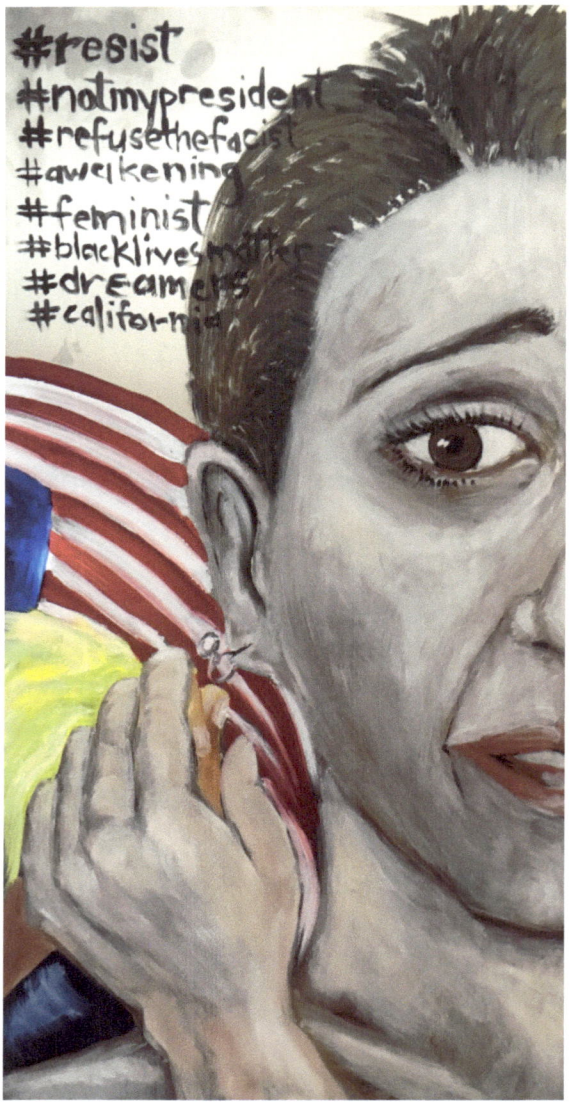

Resist Persist
30" x 15"
oil on stainless steel, nails

Ben Zask
The Faces Within

25 pieces were assembled together to form Tear Drop. Each piece can represent a different race, religion, ethnicity, or nationality. It could represent the United States, it being a land of immigrants.

The tear drop represents the divisions that keep the different groups apart and/or hostile to each other. The 2016 election braught a grave concern that the divisions will build momentum and turn to destruction in which case Tear Drop will go back to being 25 individual pieces.

Tear Drop was put together with glue and nails but we must stand together with a common bond of the belief that we are better together than divided.

www.Zaskgallery.com

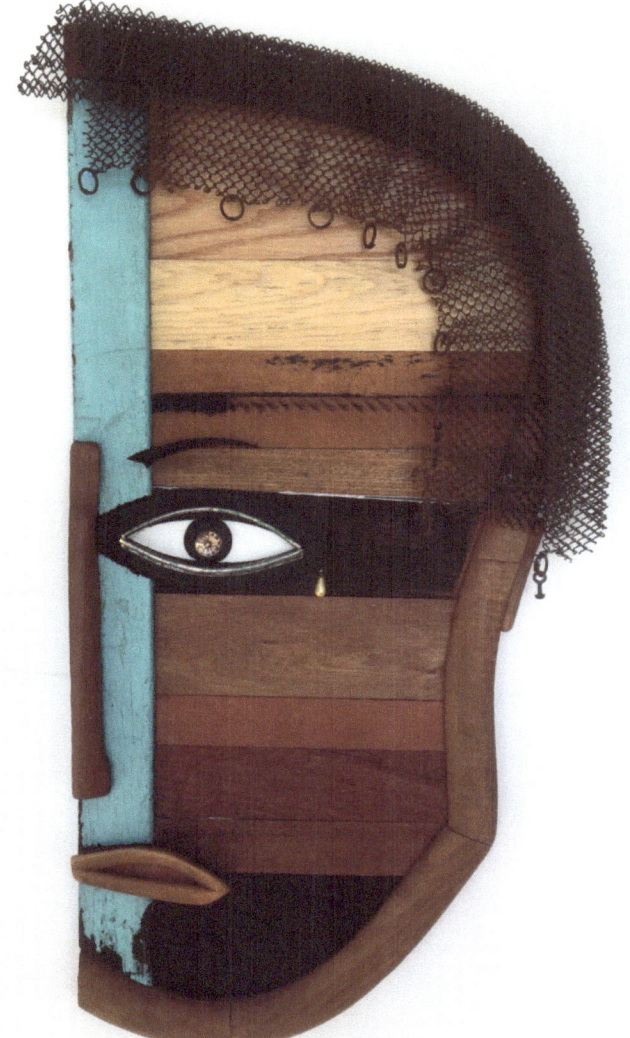

Tear Drop
30"x15"x 2"
Wood, metal, paint

January, 2017

Lore Eckelberry
The Faces Within

King Speech

On this day of change, we stand together and unite in our differences. Though I rule as a monarch, I will try to heed to the demands of my people, listen with great consideration to their concerns, and rule this country as a kind monarch. Though we all grow together to form our own oppositions and our own beliefs, we live harmoniously within those oppositions. We are in need of change. Despite of our differences always remember: we are all free, we are all equal, we are America.

www.loreeckelberry.com

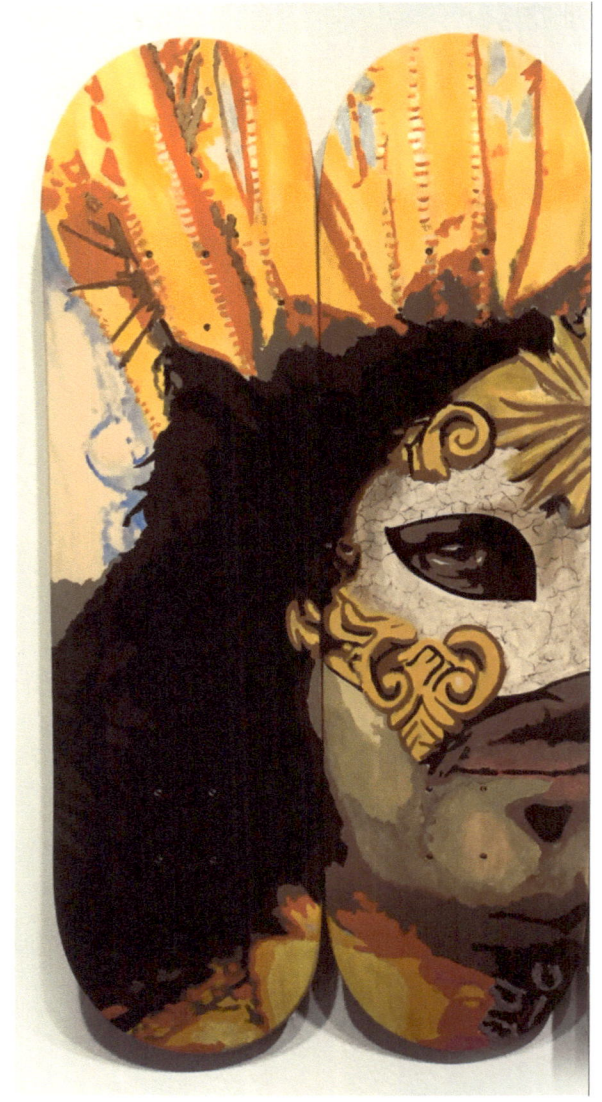

The King
32" X 16"
Mixed media on skateboard decks

Sarah Stone
The Faces Within

When asked to create this painting of my emotional and physical state during the 2016 elections, I saw an image of birds violently swarming in and out of my head, representing countless headlines, rumors, opinions and the daily informed and uninformed media predictions. The title, Terms of Venery, is a medieval phrase used to refer to groups of game, like "Murder of Crows" or "Gaggle of Geese." The word "Venery" has two definitions: the first is "hunting" and the second is "sexual indulgence." Both of these meanings seemed appropriate for the 2016 election which felt both predatory and orgiastically indulgent.

www.sarahstoneart.com

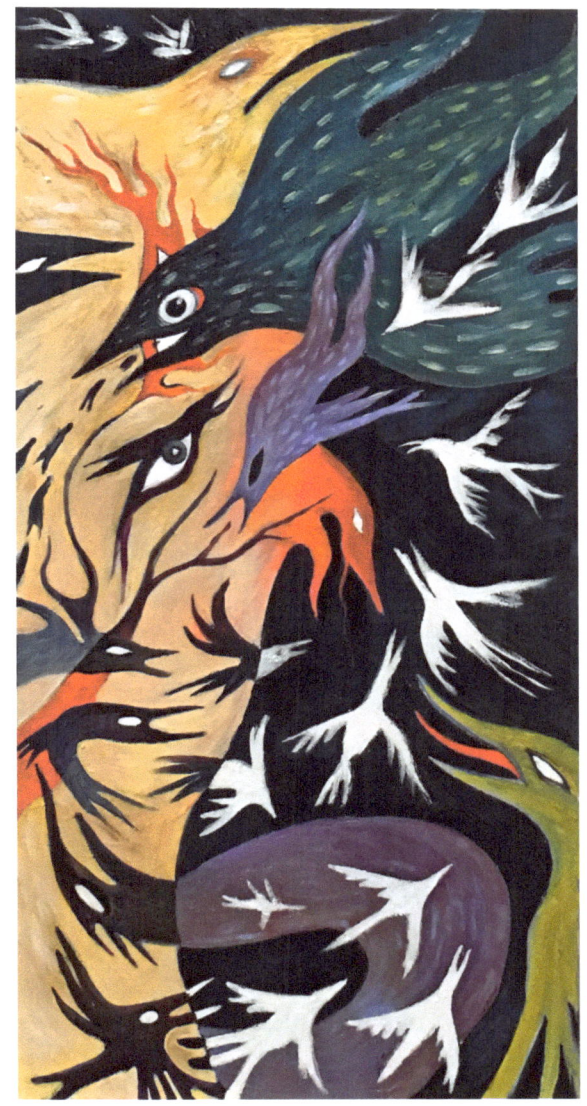

Terms of Venery
30" x 15"
Medium oil paint on canvas

January, 2017

Nancy Larrew
The Faces Within

"No One Will Believe You"
That's the little voice we hear (those of us that have been assaulted one way or another). It stops us from speaking out. It trains us to accept the unacceptable, to be easily manipulated into believing we are to blame. This election process has amplified that voice by allowing a self-proclaimed, celebrity, pussy-grabbing misogynist's behavior to be normalized into "locker talk" while allowing its implications to be overlooked under the pretense of making America great again.

www.nancylarrew.com

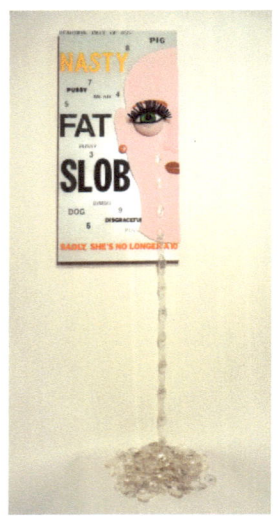

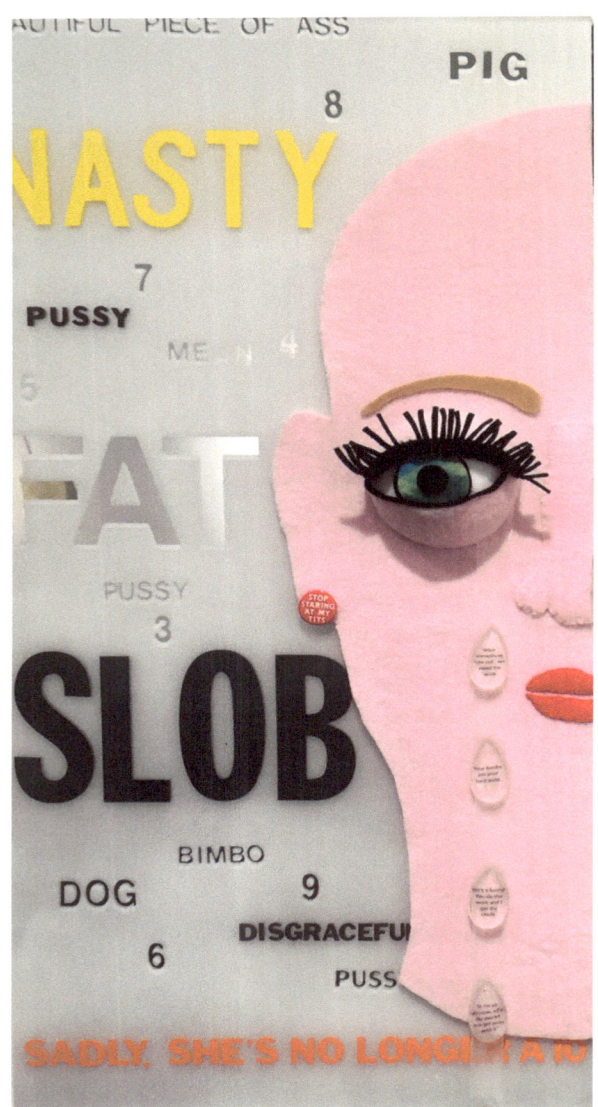

No One Will Believe You
30" x 15" plus 445 tears
Mixed Media

Randi Matushevitz
The Faces Within

Bad Dream

My scared face is ghostlike with
Hair on end
Lips sewn shut
Voiceless grunt

Flames around the corner
No smell of smoke
Lies, false facts, false hope
No sight of smoke

Ashes of oblivion
Americans hide, some fight
See them
You are them

www.randimatushevitz.com

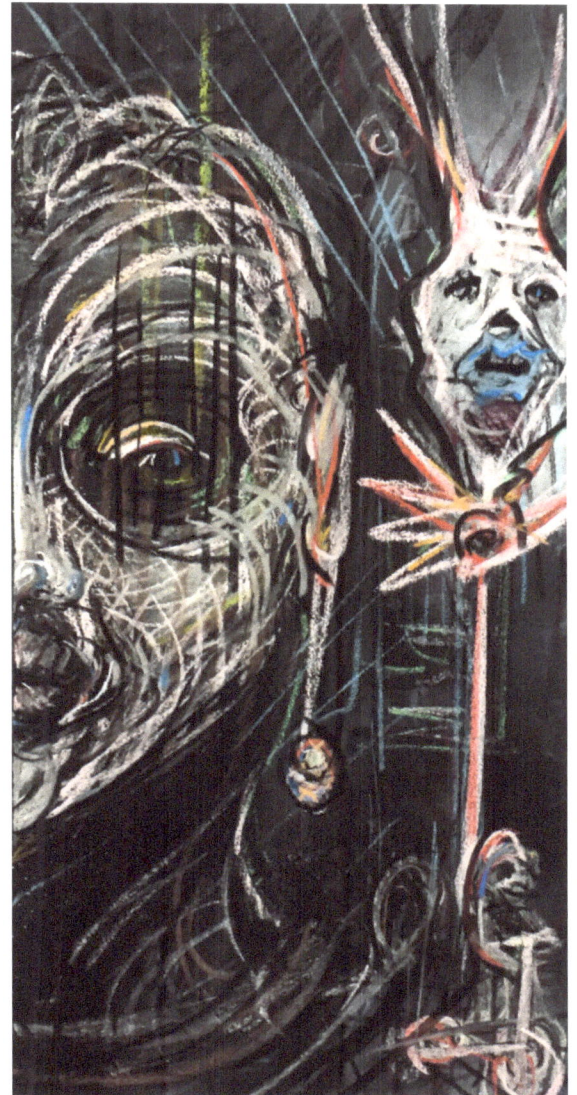

Bad Dream,
30" x 15"
Charcoal, Pastel, and Paint,

January, 2017

Malka Nedivi
The Faces Within

"My parents were Holocaust survivors, and this background has made a deep mark on my life. I am worried about our country's future, and about people becoming extreme. I am worried about not learning from history, and history repeating itself. I am worried about building a shell and staying there without caring about other people or the world. I am filled with worry. We are not alone. We have to learn. Know. Care. Accept the differences. And hug each other. Only together with acceptance will we make the world a better place."

www.malkanedivi.com

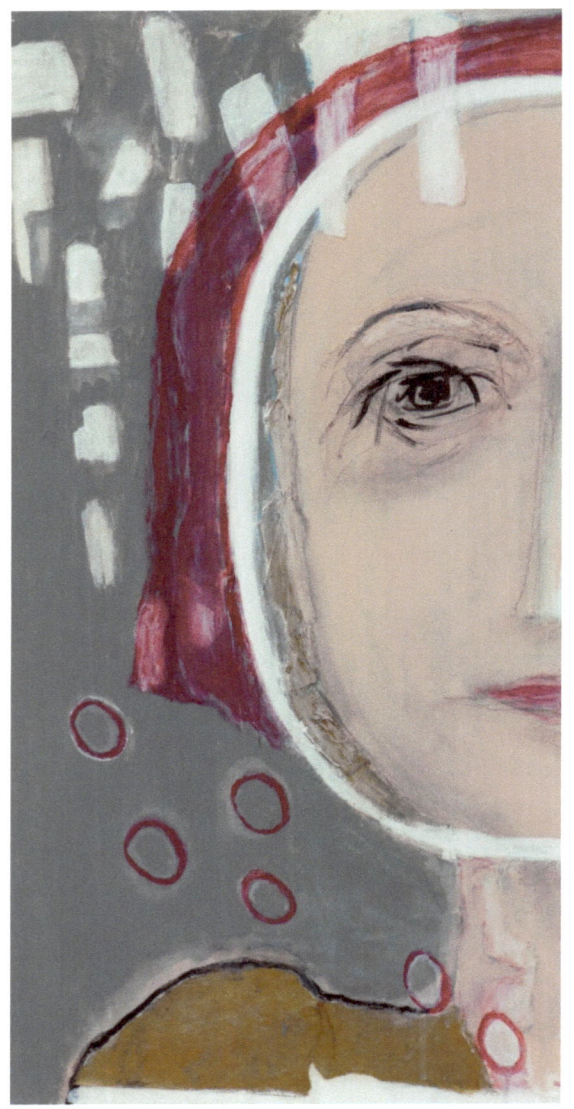

it's a new year
30" x 15"
mixed media

Leonard D Greco
The Faces Within

Fear & Loathing

It is the shadowy underbelly of man that I fear; base instincts that civilized society approaches with restraint. This malignant darkness that heretofore clung to dank corners, now, with the ascendancy of this reptilian man have the courage, even encouragement, to raise their battle standard. Their clarion call is loud and it is shrill.

 Its shrillness cuts through me like a knife, I fear the light will be eclipsed by barbarism; hence my hirsute fellow, intent upon silencing the (feminine) moon with his testosterone fueled rage.

This I fear is a dark new world.

www.leonardgreco.me

Fear & Loathing
30" x 15"
oil on canvas

January, 2017

Artists: *The Faces Within*

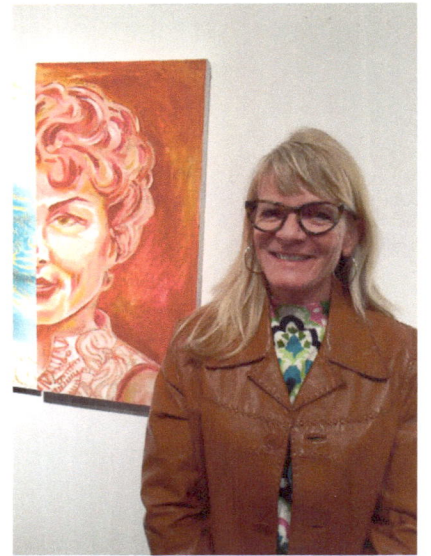

Anna Stump

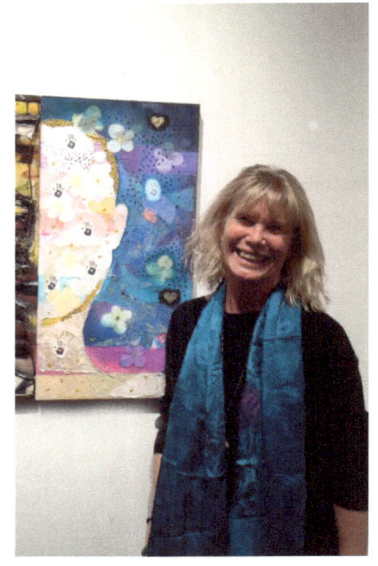

Beanie Karman

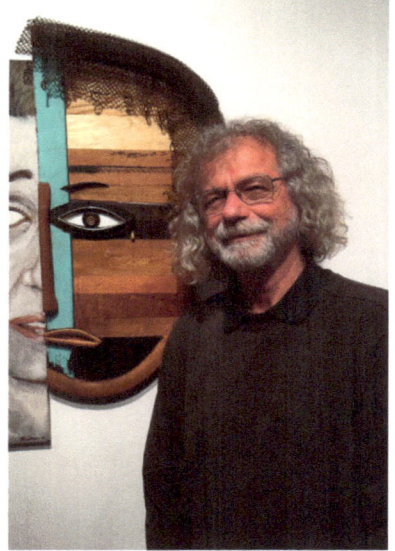

Ben Zask

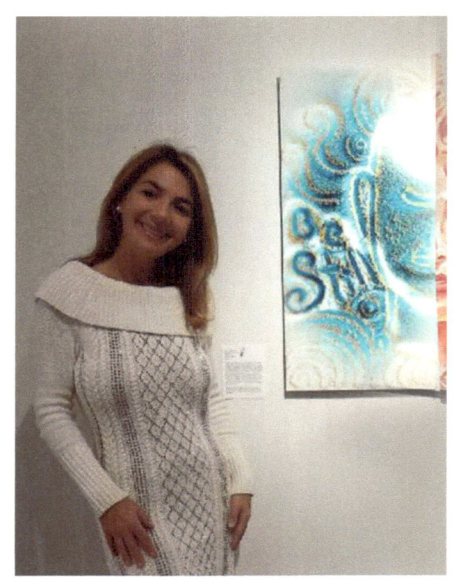

Cansu Bulgu

Artists: *The Faces Within*

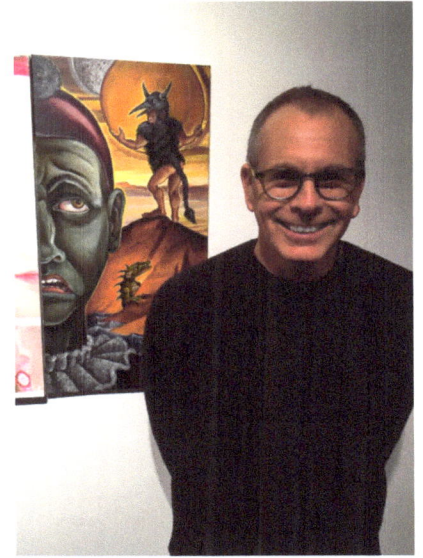

Leonard D Greco, Jr.

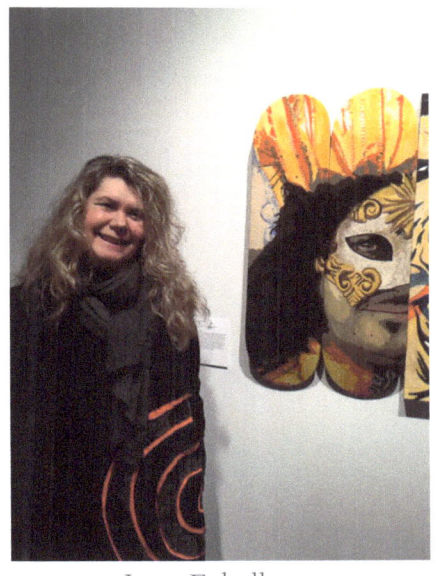

Lore Eckelberry

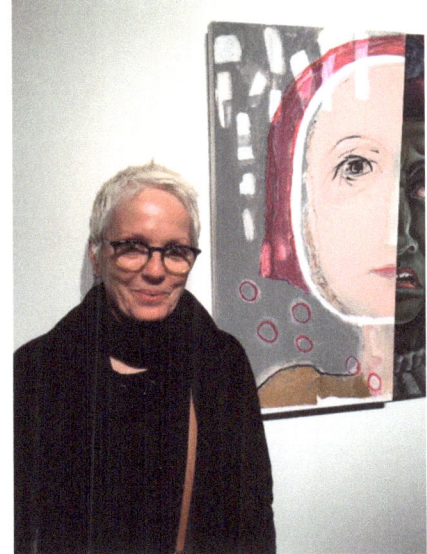

Malka Nediv

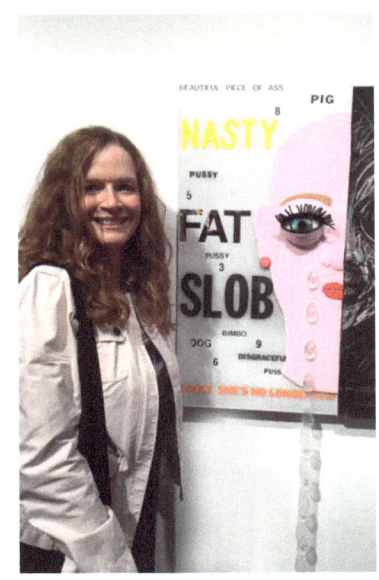

Nancy Larrew

January, 2017

Artists: *The Faces Within*

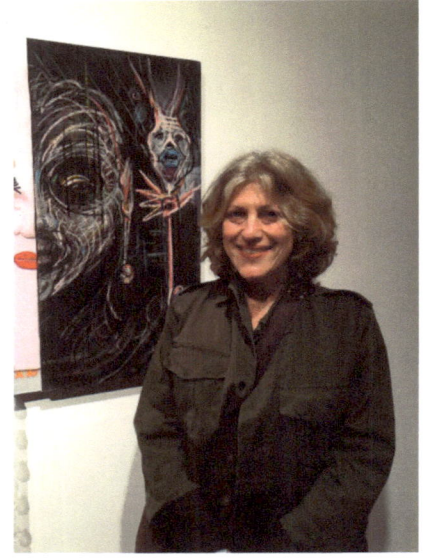

Randi Matushevitz

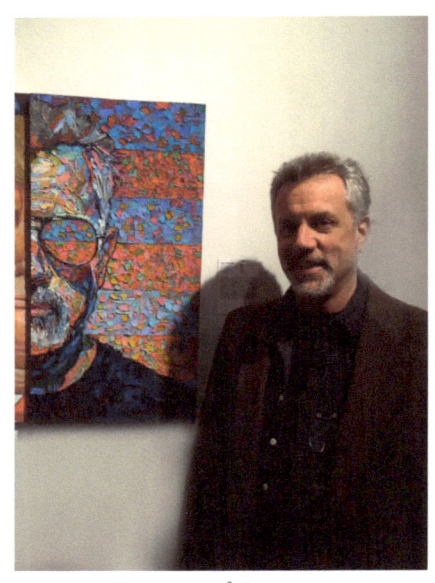

Raymond Logan

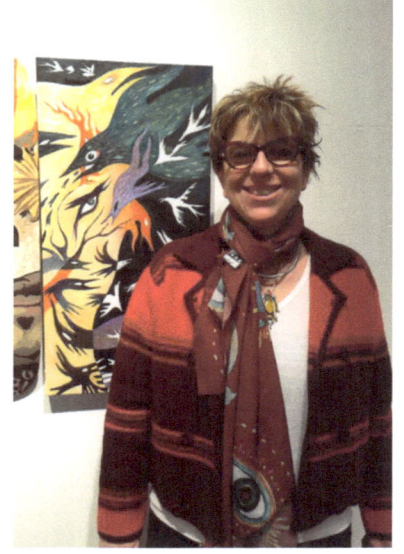

Sarah Stone

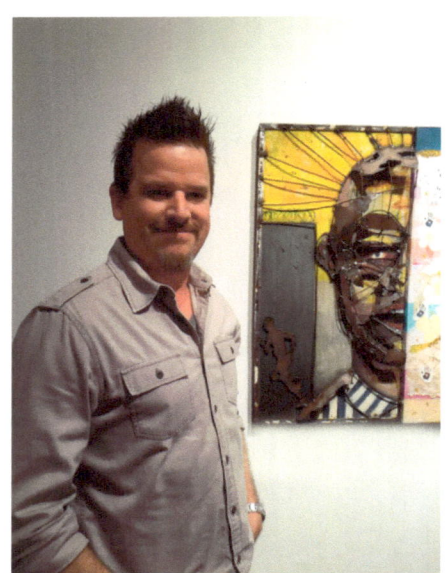

Scott Meskill

Artists: *The Faces Within*

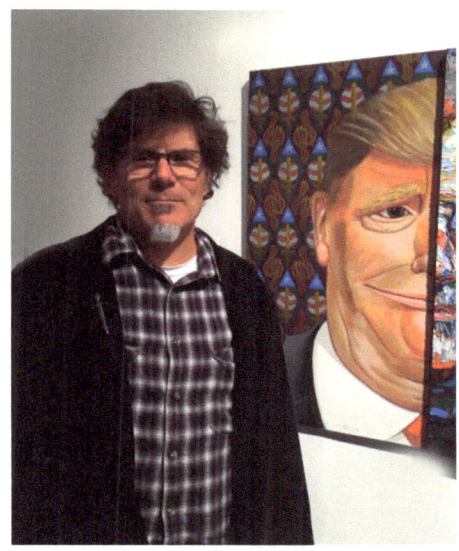

Steve Shriver

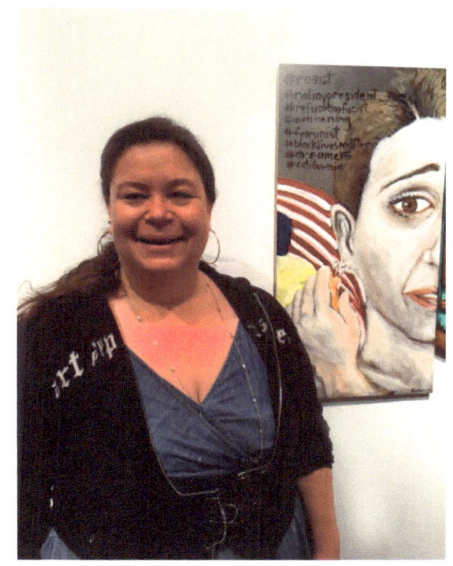

Vicki Barkley

January, 2017

The Faces Within

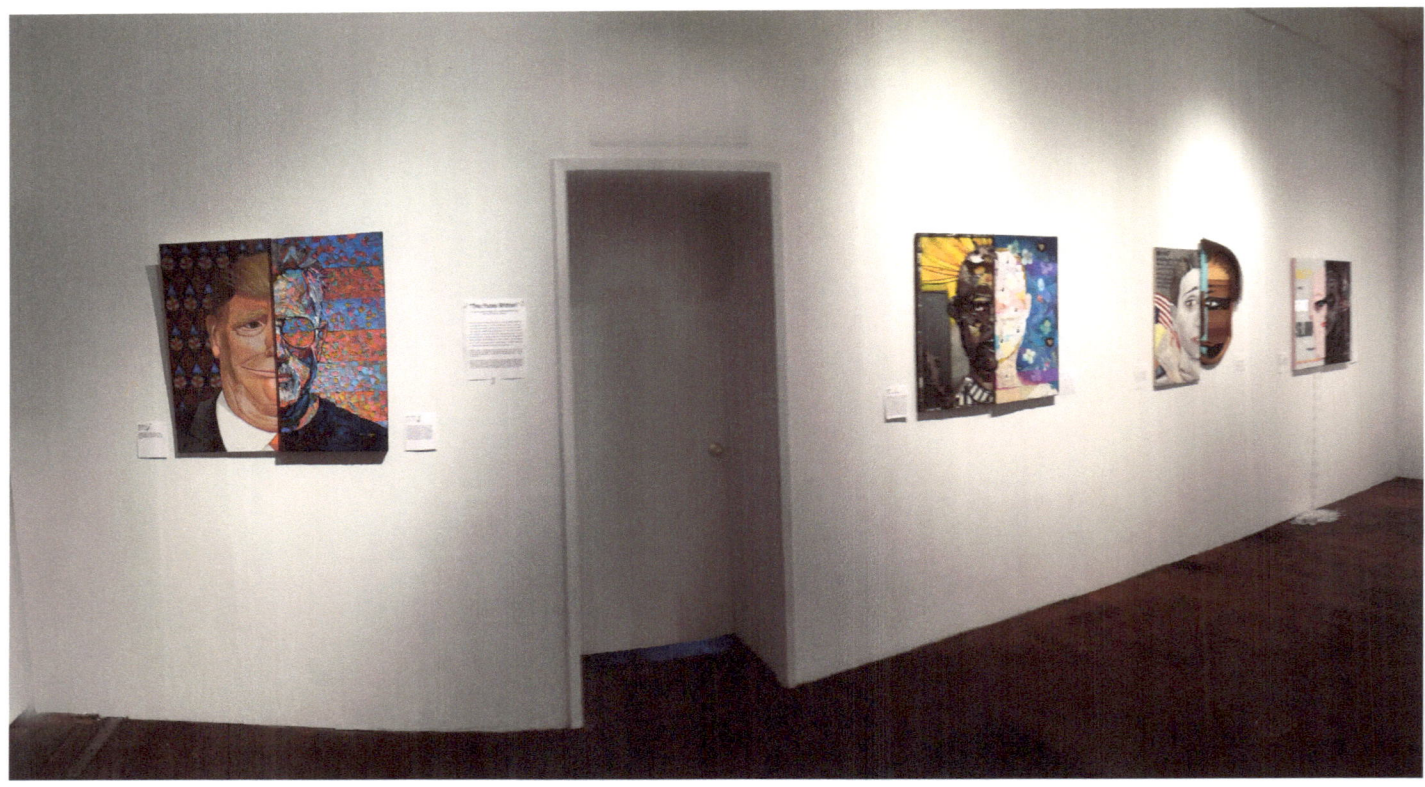

The Faces Within

The Faces Within

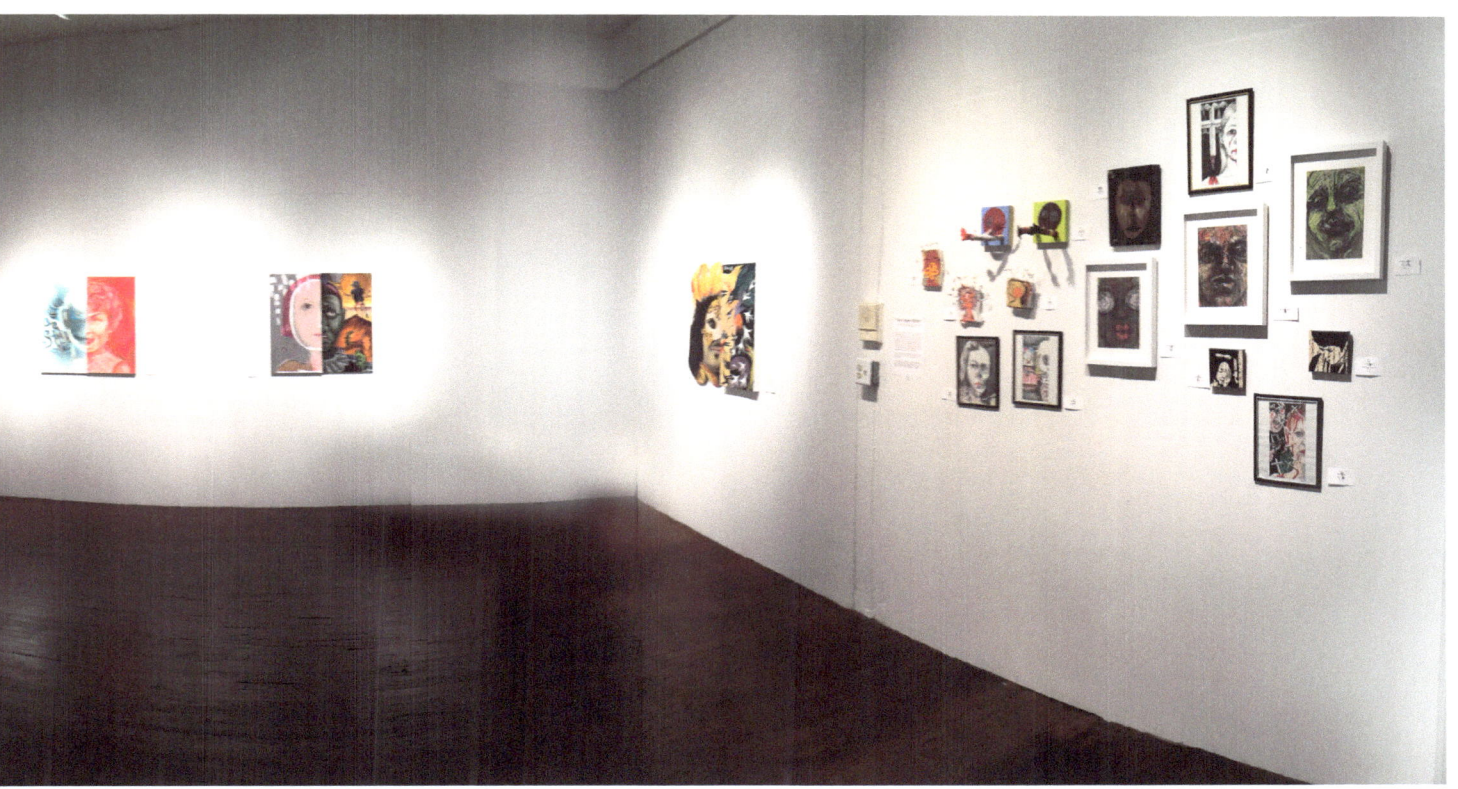

January, 2017

The Faces Within

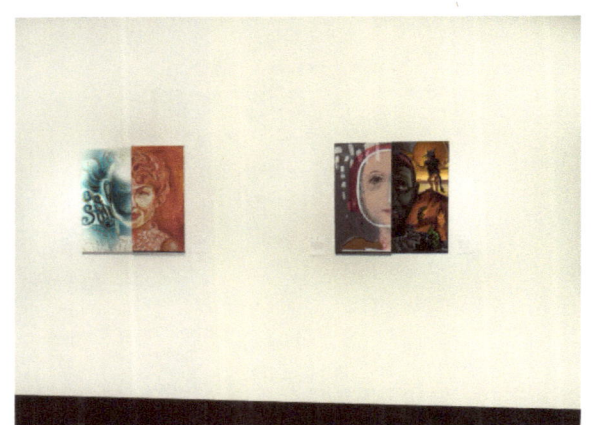
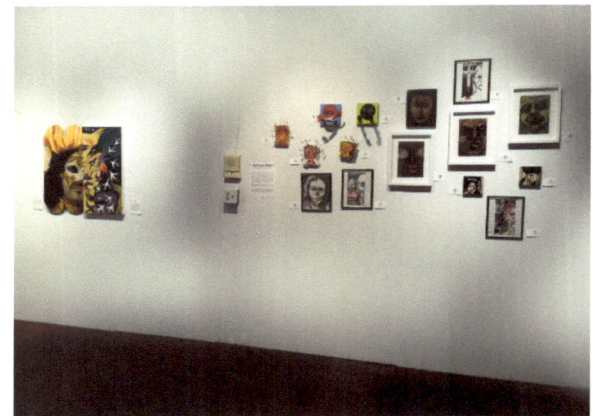
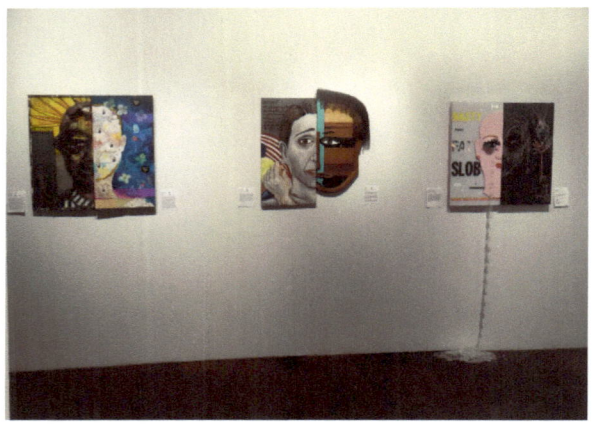
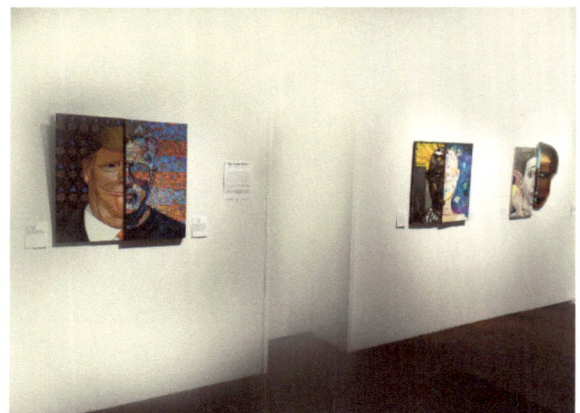

www.ingramcontent.com/pod-product-compliance
Lightning Source LLC
Chambersburg PA
CBHW041318180526
45172CB00004B/1145